ANIMA

PHOTOGRAPHY & TEXT BY

ANIMA

JAMES BALOG

Arts Alternative Press·Boulder, Colorado

For Simone,
with love

CHIMPANZEES.

By human definition,
they are nature and we are not.
But the difference is slight.
Their genes and our genes are
98.4 percent identical:
chimpanzees are
more closely related to humans
than they are to the other apes.
They have cognitive and reasoning abilities.
They use tools.
They are altruistic and they make war.
They experience joy.
And sorrow and pain.
And fear and pleasure and anger.
And love.

They become a window
through which to re-examine
our conceptions of
the boundary
between humans and nature.
Can these conceptions,
inherited from times
and places
and circumstances
radically
different than ours,
still be valid?

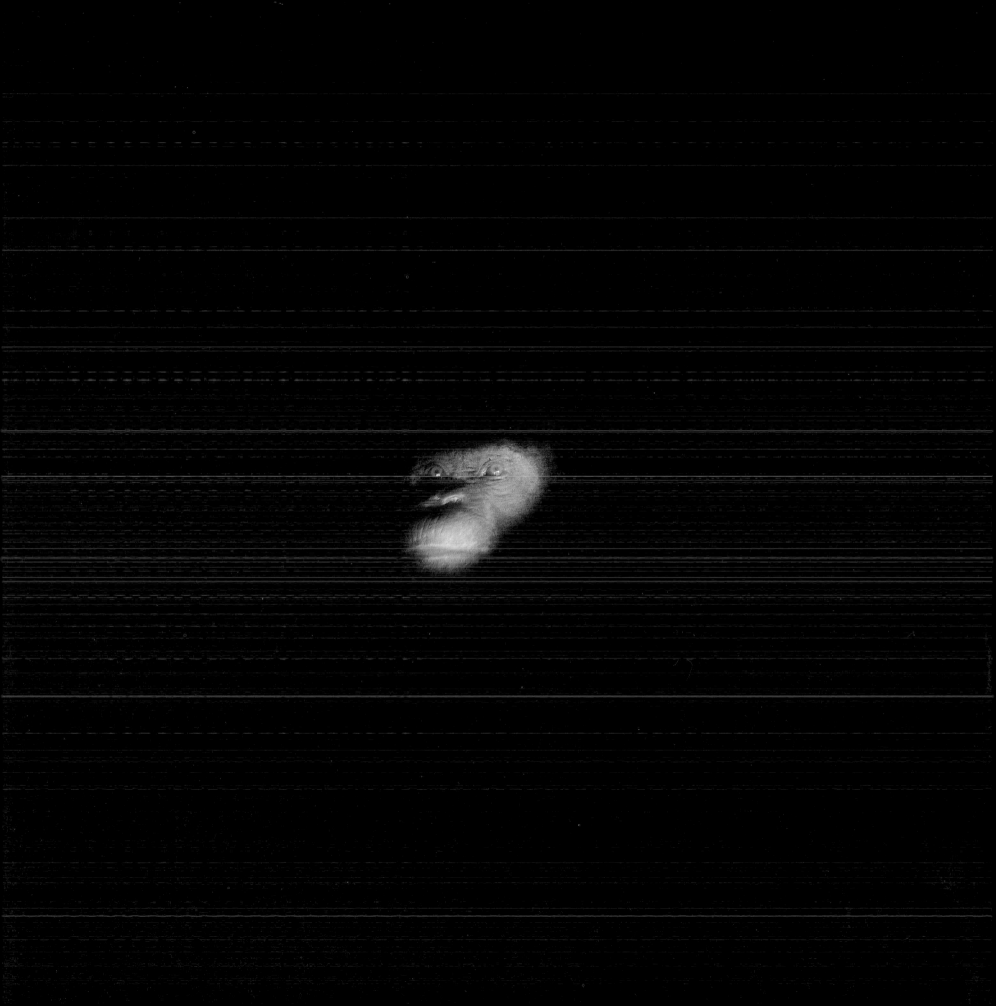

The *TURNING* of the millennial tide is upon us.

The West's ancient world vision has been

dissolving,

eroding,

mutating

as fast as it is accreting.

The vision has left us with much that is good.

And

it has left us with

fatal oppositions:

humanity *AGAINST* nature,

mind against body,

the conscious against the unconscious,

science against soul,

religion against sexuality,

youth against maturity,

masculine against feminine.

Continents are denuded,

plants, animals and primal civilizations

have been exterminated,

and

the *SELF*

is vaporizing in an electronic cloud of

image and illusion,

fantasy and projection,

profit and consumption.

The *BEAST* has slouched to Bethlehem.

ANIMA:

Latin for soul,

metaphor

in myth and dream

for the feminine

within

the masculine,

for the spiritual

within

the rational,

for the natural

WITHIN

the human.

And symbolized

in the unconscious

by animals.

Fed by the tension

between

human life

and the life of nature

surrounding us,

created in response

to oppositions,

this work

seeks

REINTEGRATION.

Its name, its face, its behavior: US.

9

We

were never cast

from *Paradise*

as our traditions claim.

Rather, Western Civilization,

and a thousand humanoid cultures

before it,

simply invented

the peculiar idea

that in this

whole

Whirling existence,

humans were the only entities

which were not

nature.

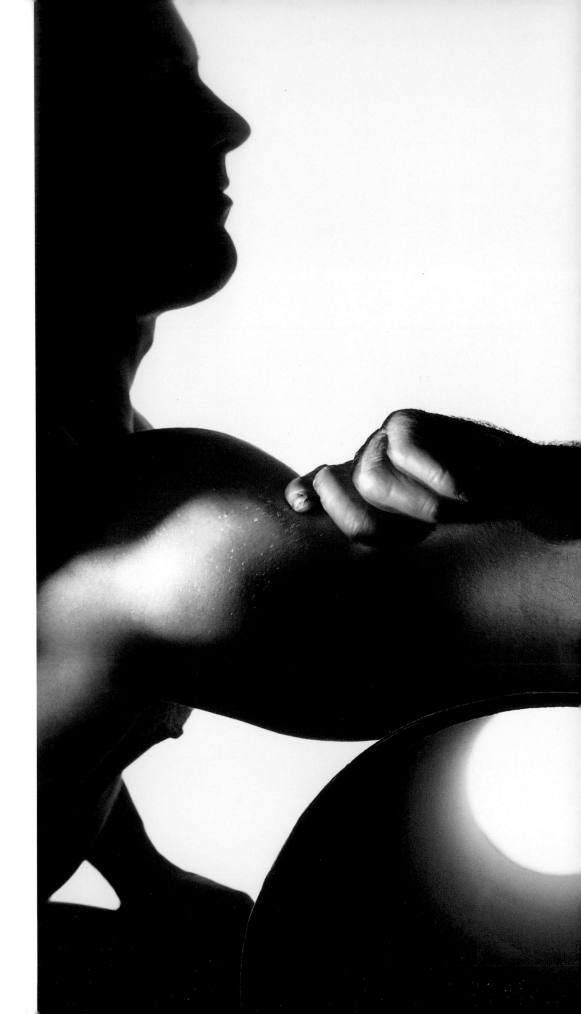

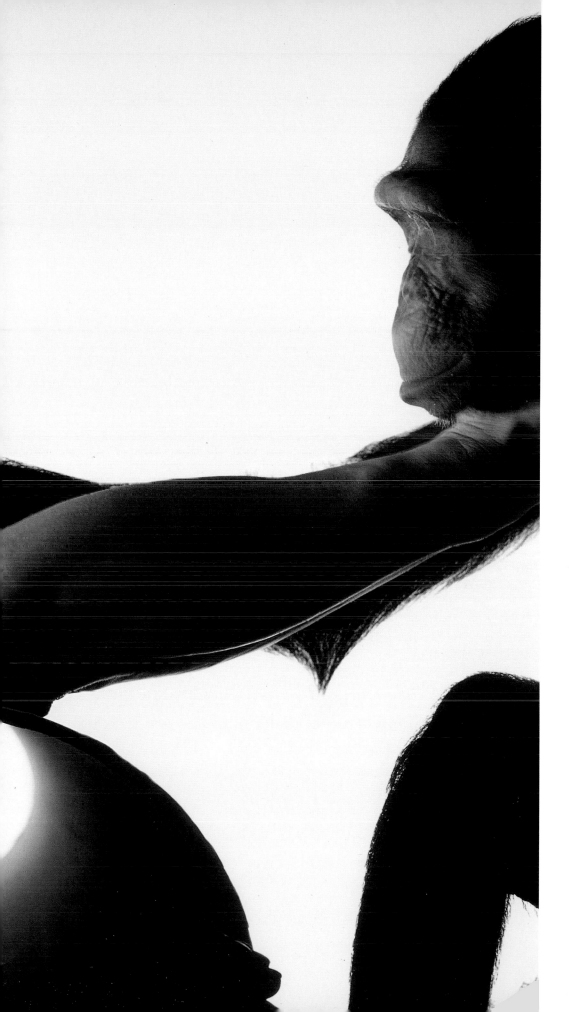

An idea
which might
have *Once* been
constructive,

healthy

and

adaptive,

has *Today*

become

a

trap.

If our external structures

derived from apes

and are still so like those of apes,

why should our internal structures,

the *dreams*,

the *emotions*,

the *symbols*—

not also be similar?

What if spirituality is

the animal mind

at work,

using its supra-conscious

sensing ability

to detect powers

beyond rational perception?

What would this say about the

myth of *Eden*?

Did animal mind conjure it?

Or did it exist?

Is it an artifact of a time

when animal mind did not perceive

the *struggle* of the fittest as a

horror?

Did animal mind *change*

to human mind

the moment that acceptance

of natural processes

turned to revulsion?

Was that the moment

when the collective psyche,

forced to survive in the midst of

horror,

rejected nature

and our position

within it?

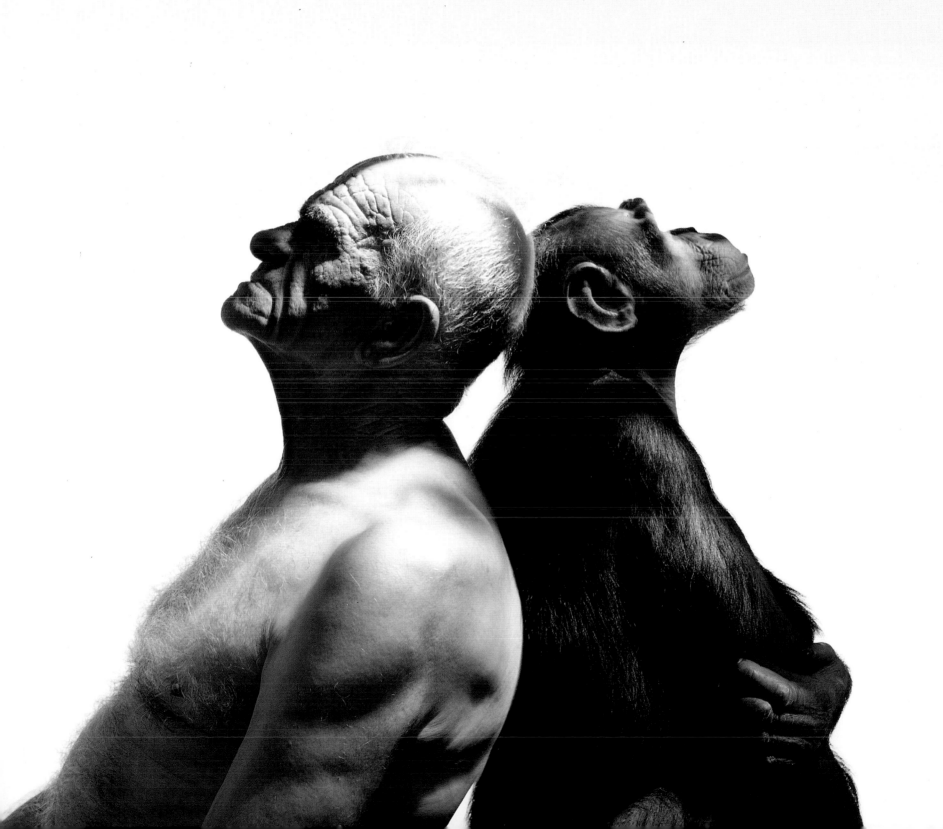

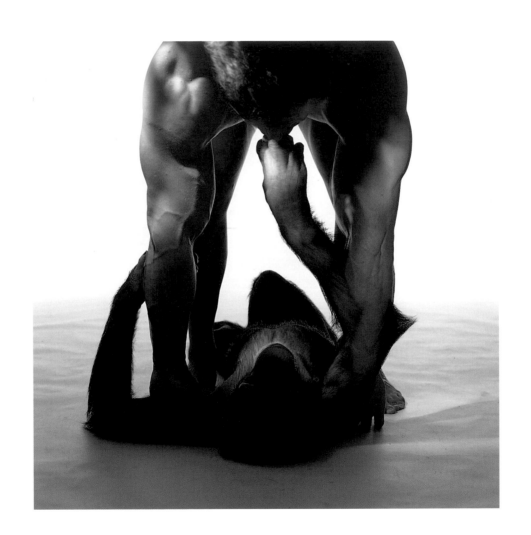

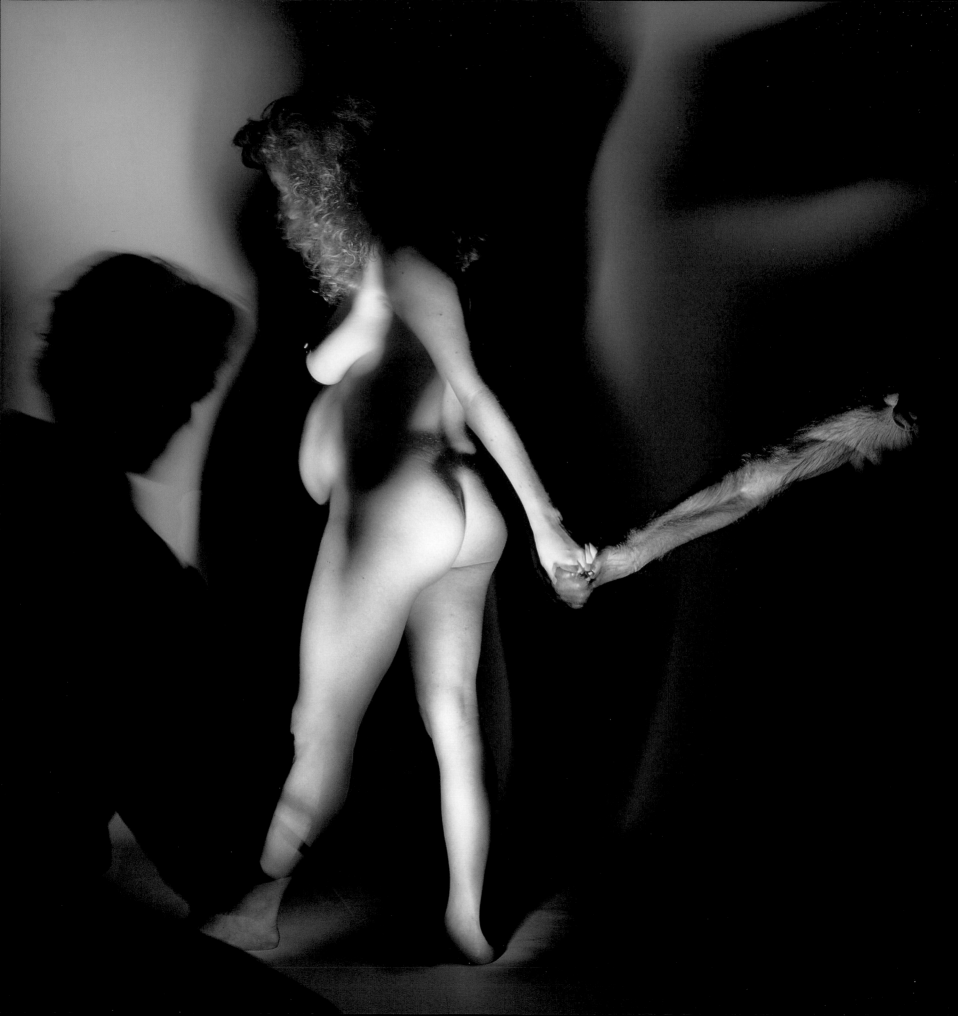

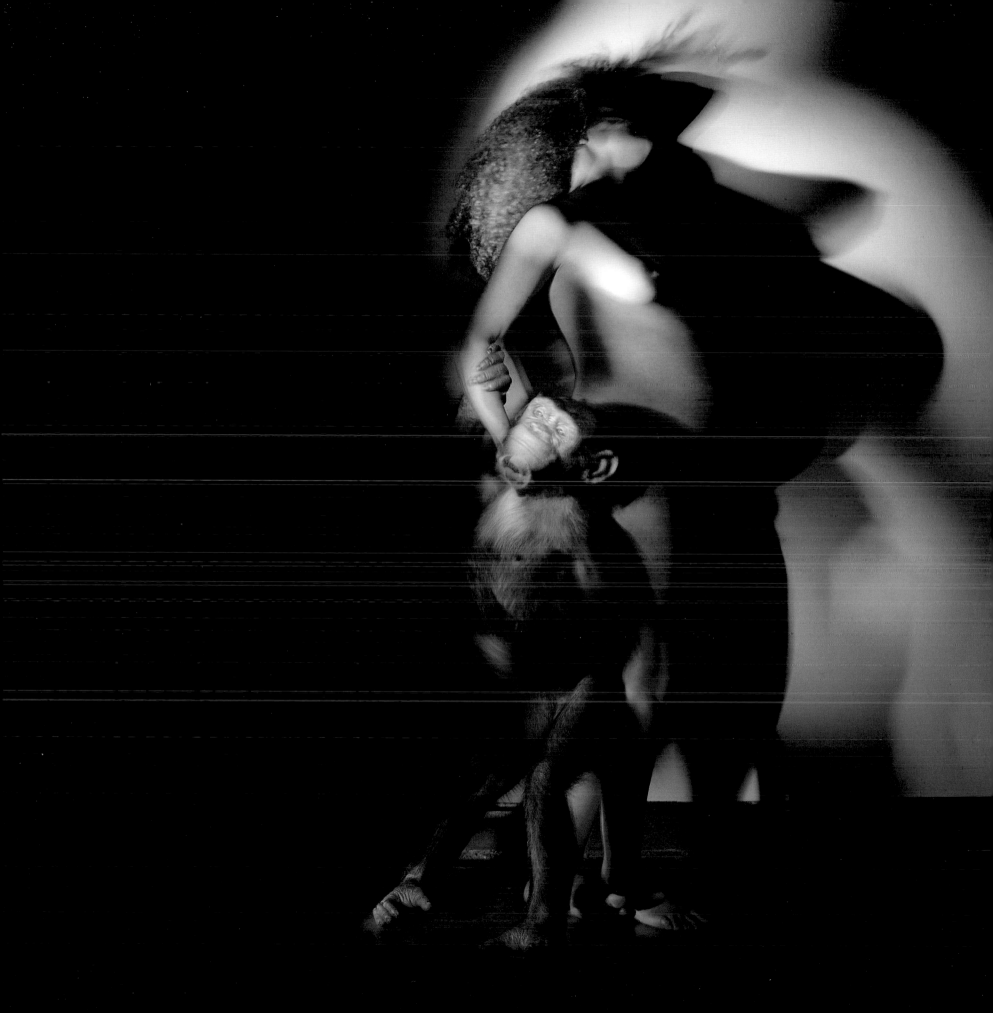

The

Homo genus

needed more than

three million years

to understand its ***Basic***

physiology.

How long, then,

to understand the

psychological

labyrinth?

on

How long before the

our *Narrow* view of

consciousness seems as misguided

as medieval arguments

about the number head

of angels that

can *Dance*

of

a

pin?

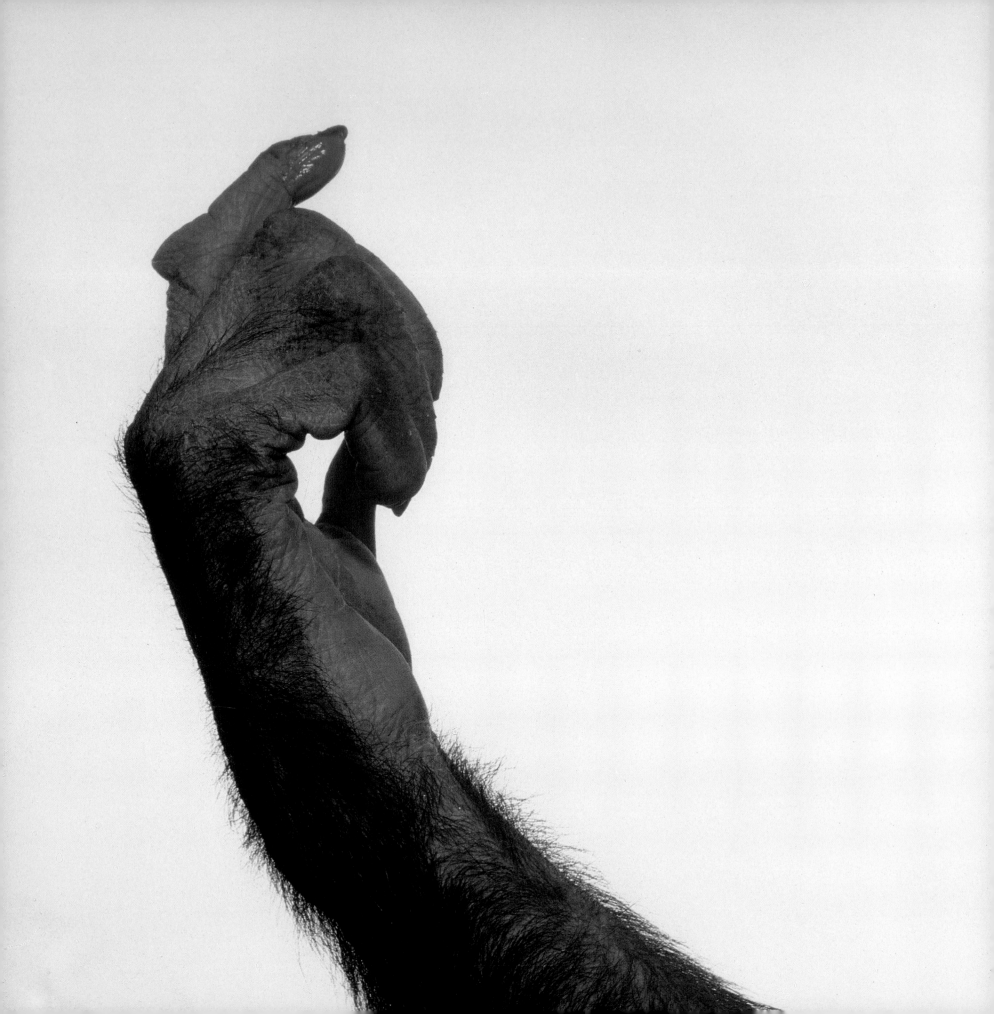

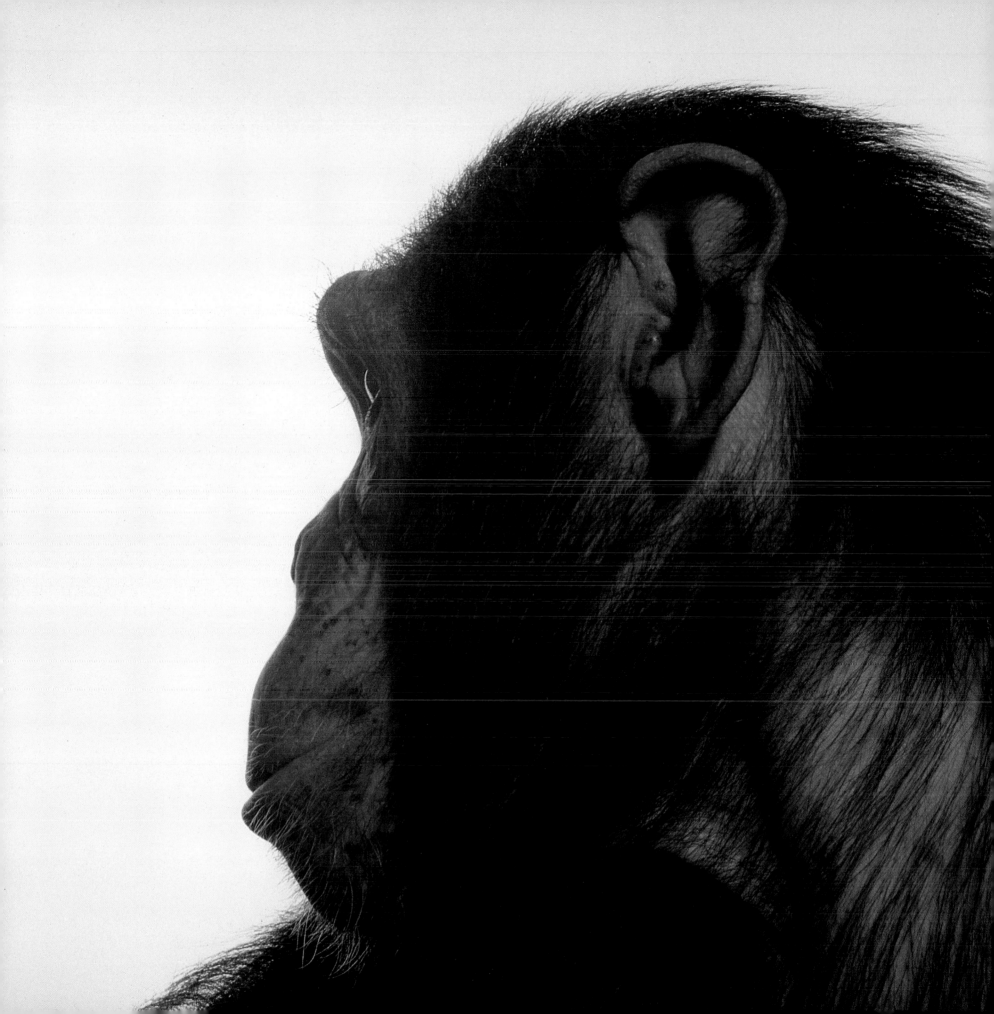

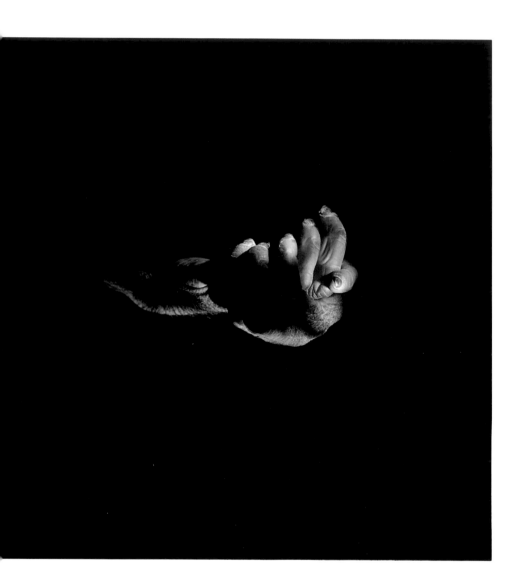

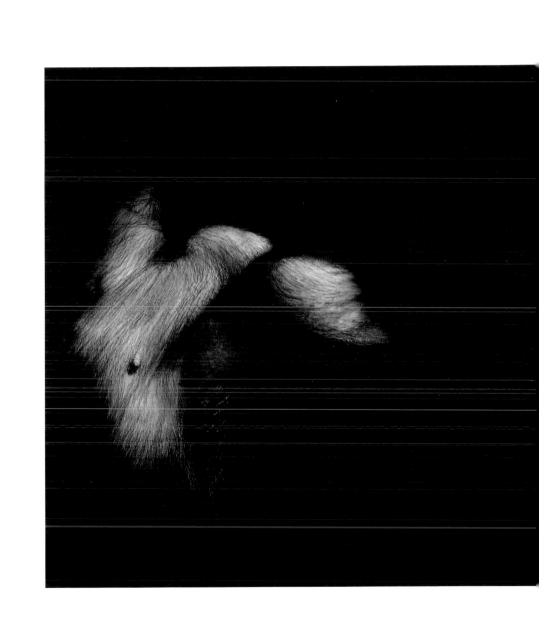

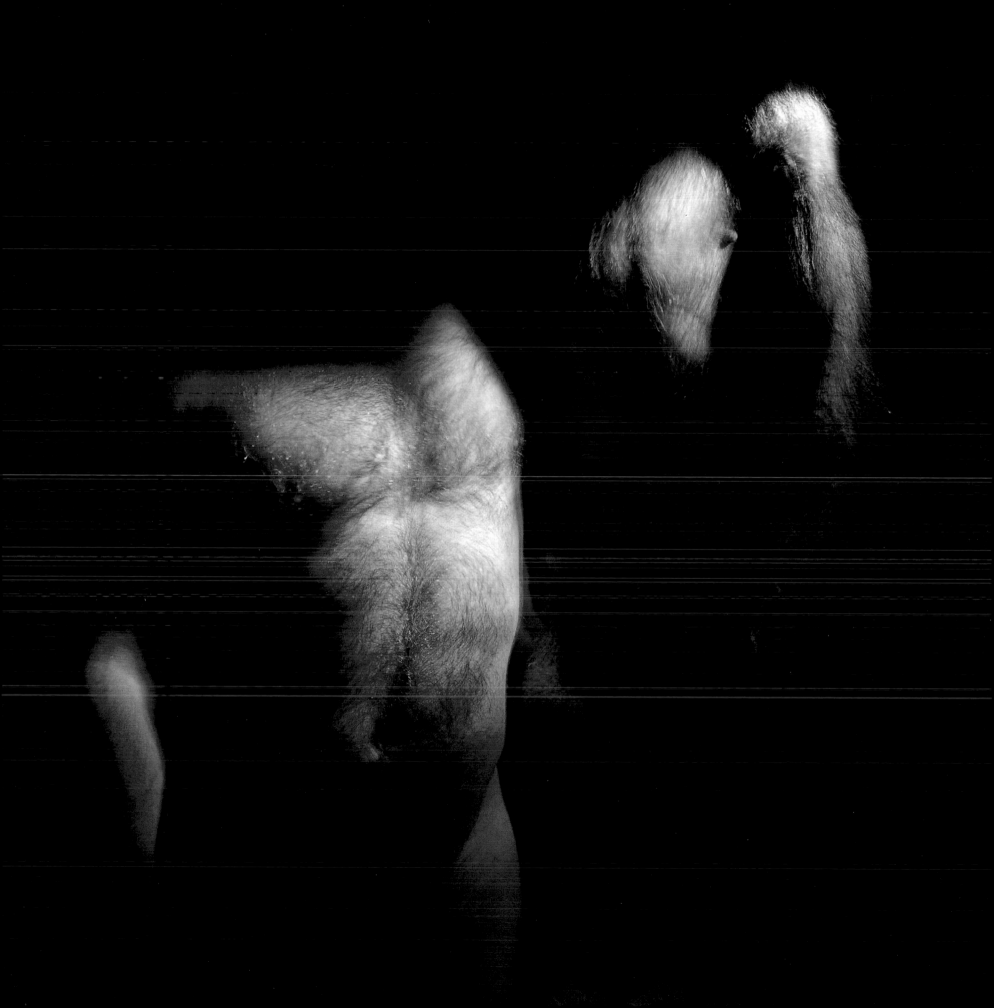

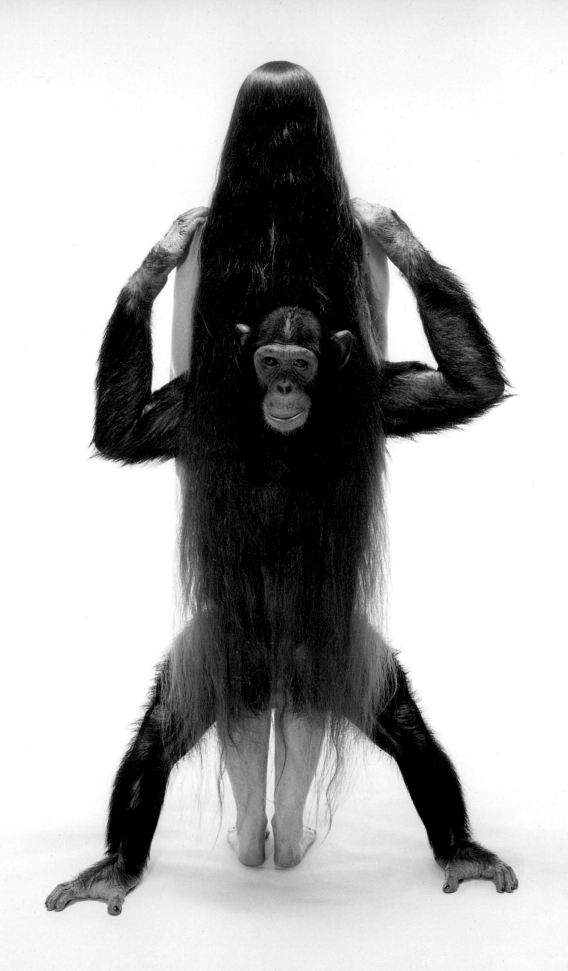

In the West,

we have been masters

of

sensual repression.

Once we became

skilled

at dismembering

the internal, personal

World,

how easy it has been

to do the same

to the

external world,

especially nature.

With its

wanton randomness

and

its blood

and

its dirt

and

its passion,

Nature

is

an affront

to

delusions

of

decency.

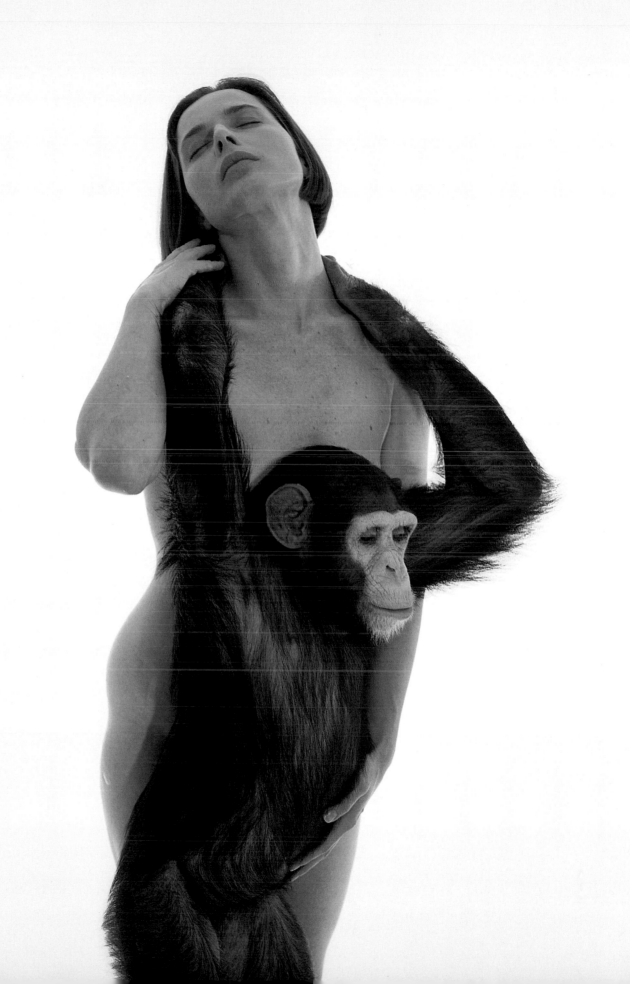

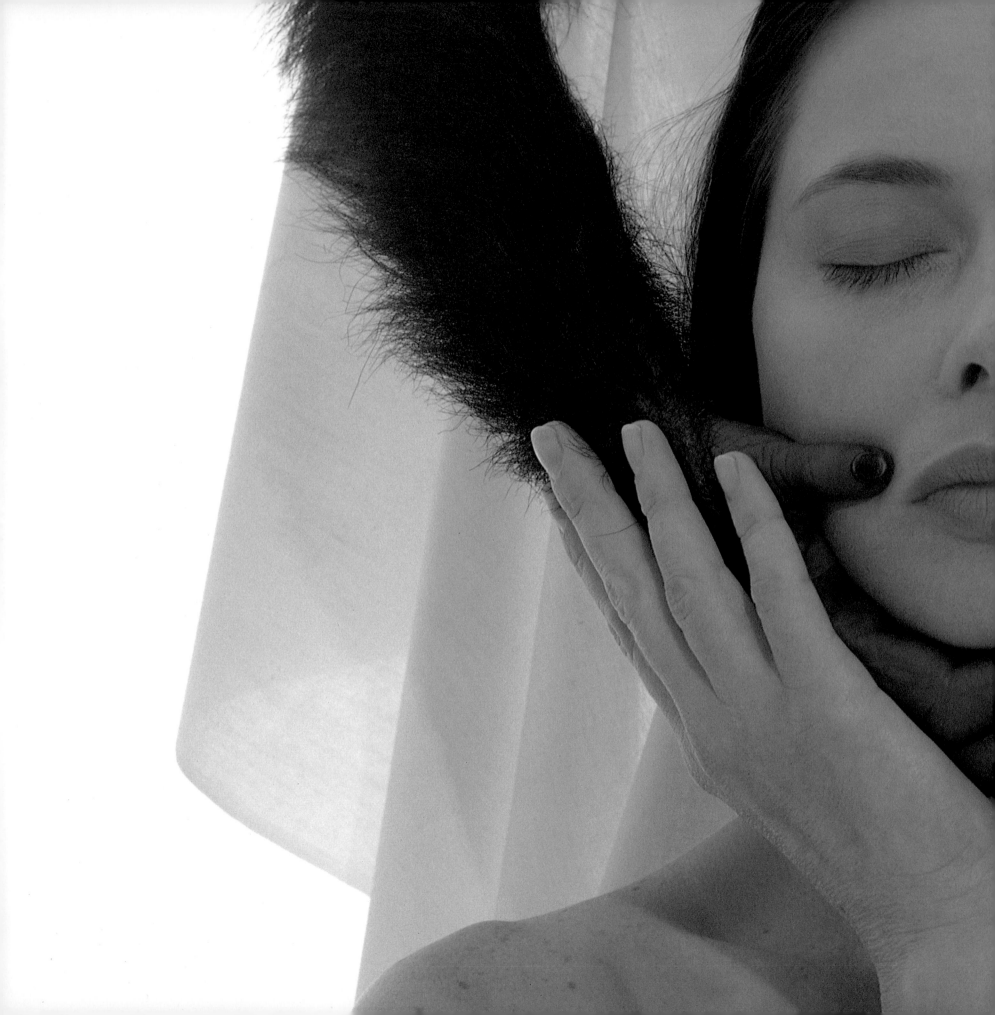

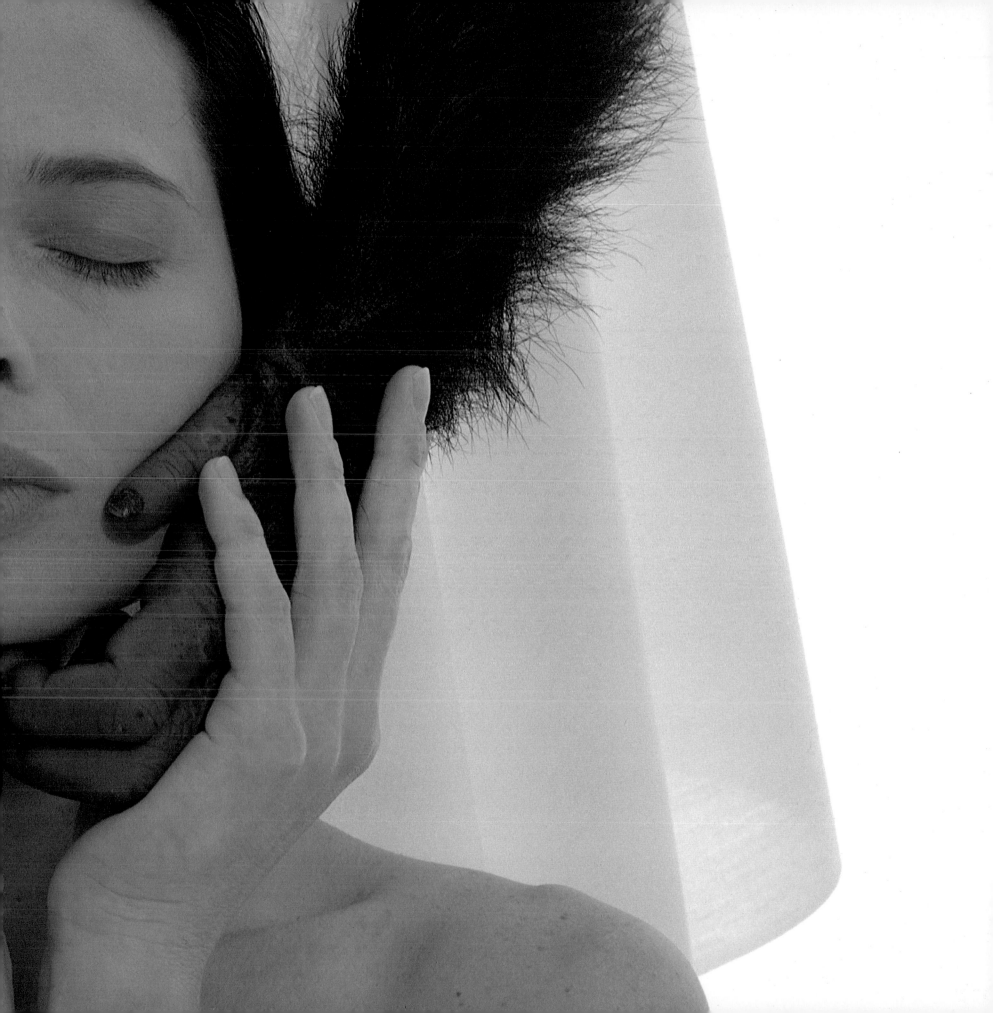

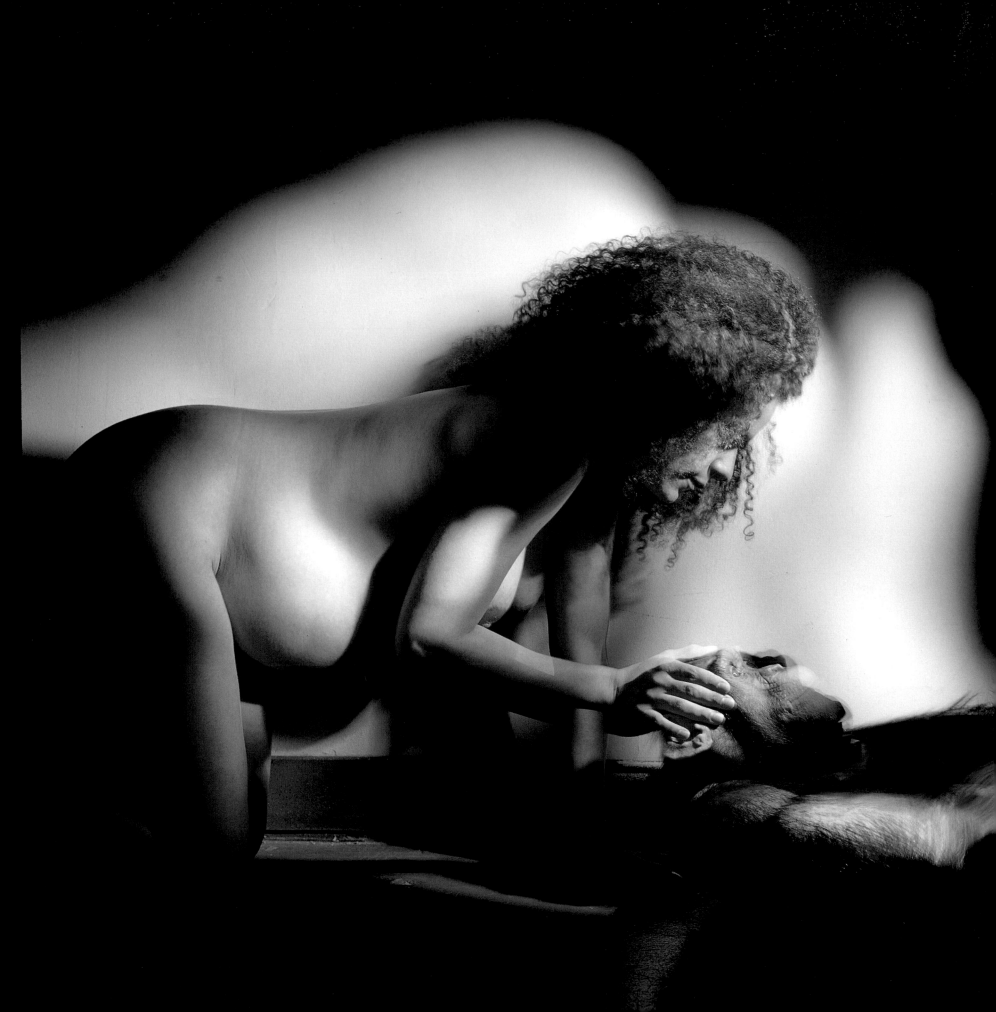

The *Schism* between

humanity and nature

is found

at the small and particular level

within

individual humans:

it is the *Gap* *between mind and body,*

and it is caused

by the simple act

of

thinking.

Thinking creates a rift

between

the physical self

and the surrounding world.

Fully **Sensory** *(or fully natural) experience is impossible during thought.*

A *Twilight*

of mental projections

replaces the natural.

The basic conundrum:

is

mind

inherently

in

O*pposition*

to

nature?

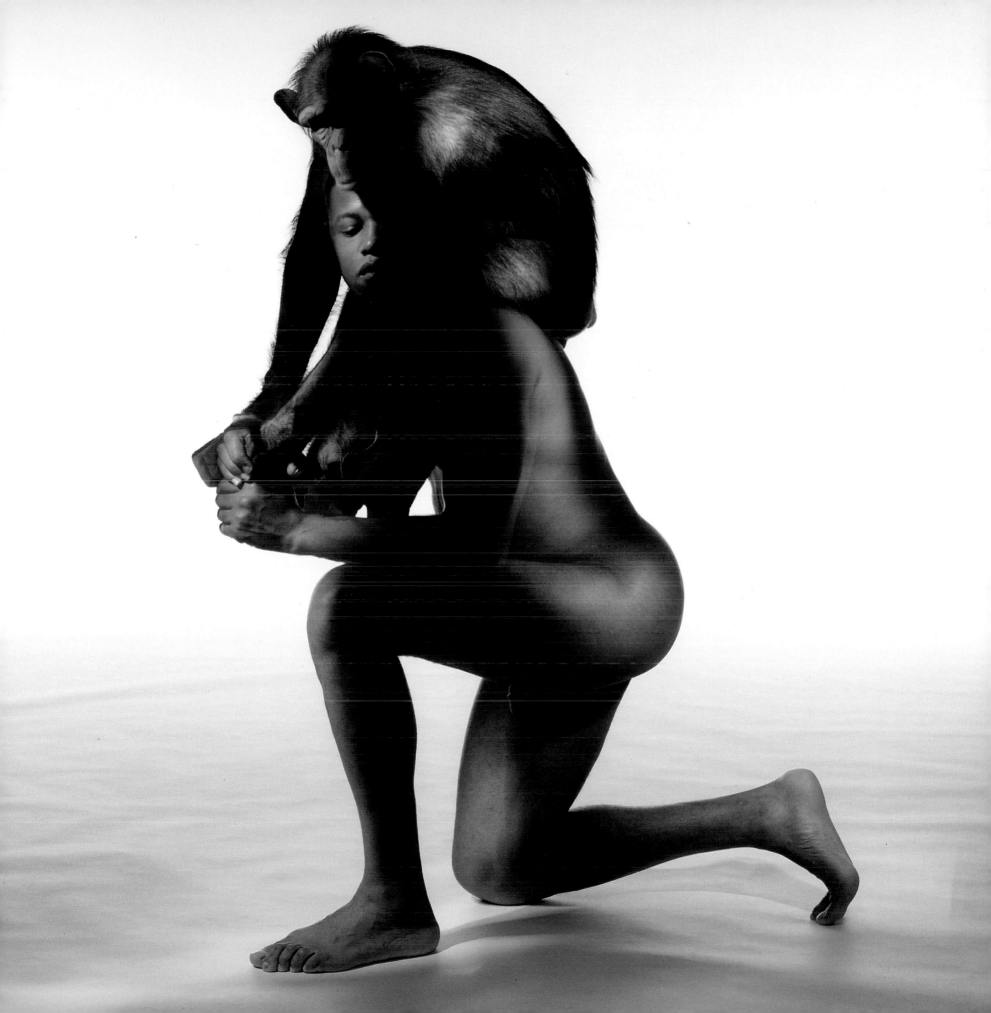

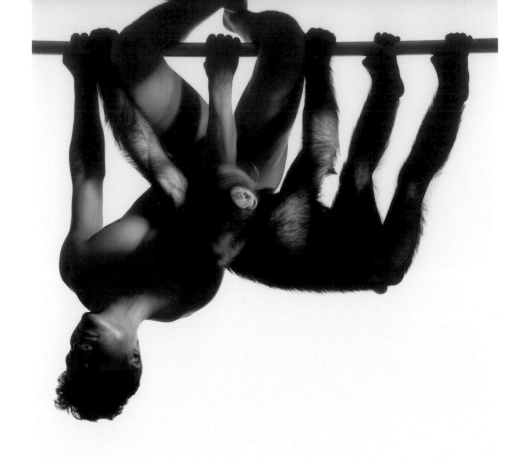

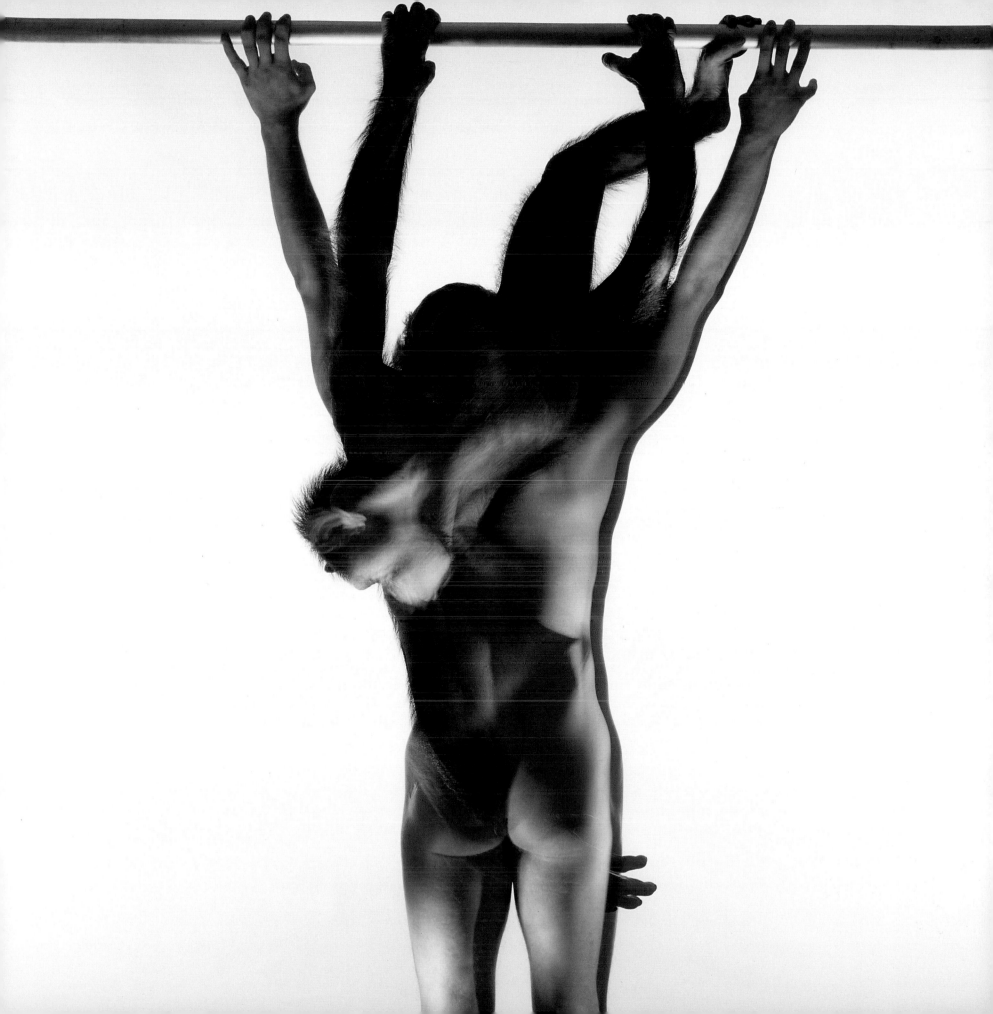

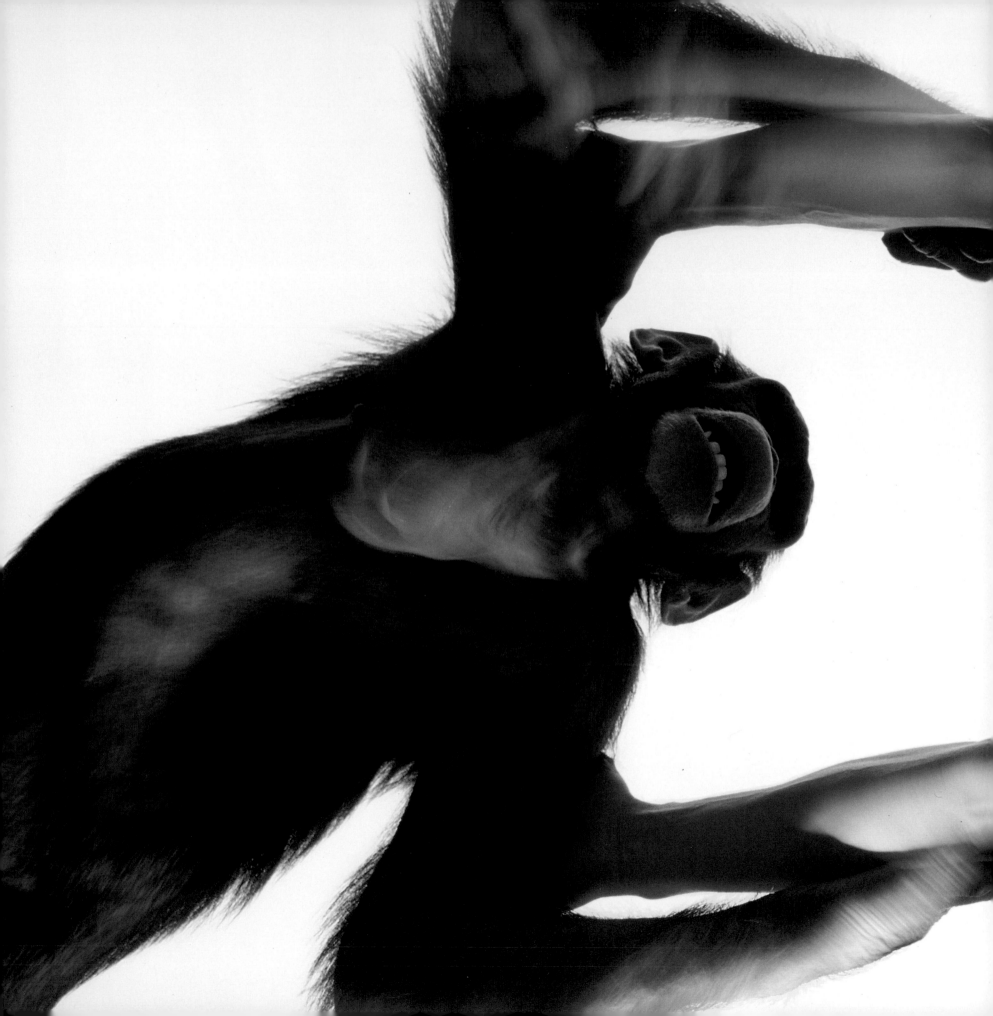

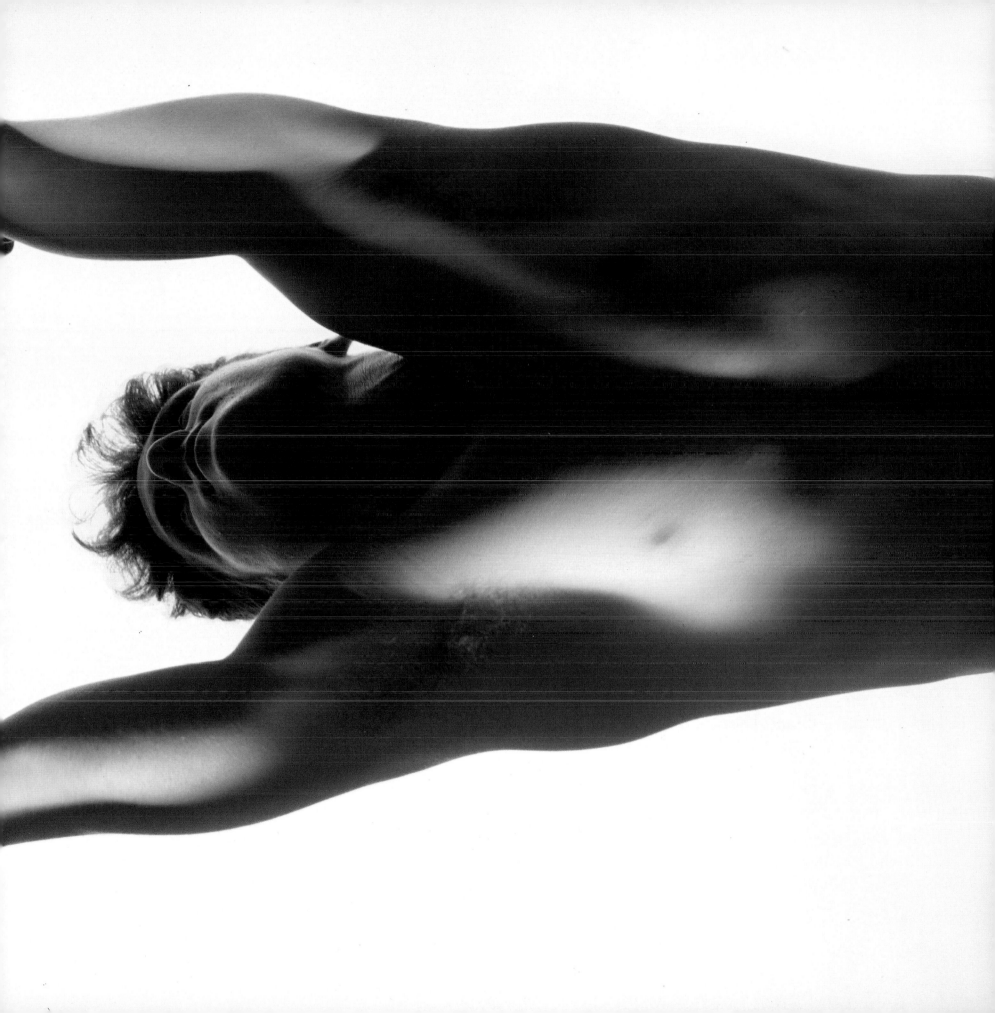

Her presence

is overwhelming.

Each motion is

as precise and deliberate as Zen,

unruffled and contained.

How far beyond what I can know

does her mind reach?

How are her memories,

dreams, and reflections

rendered in her brain?

That I am in the presence

of a complex *Psyche*

I have no doubt.

But primitive larynx

and primitive vocabulary

constrain potential.

How does fate govern

whether soul becomes embedded

in *Human*

or

in *Animal*

form?

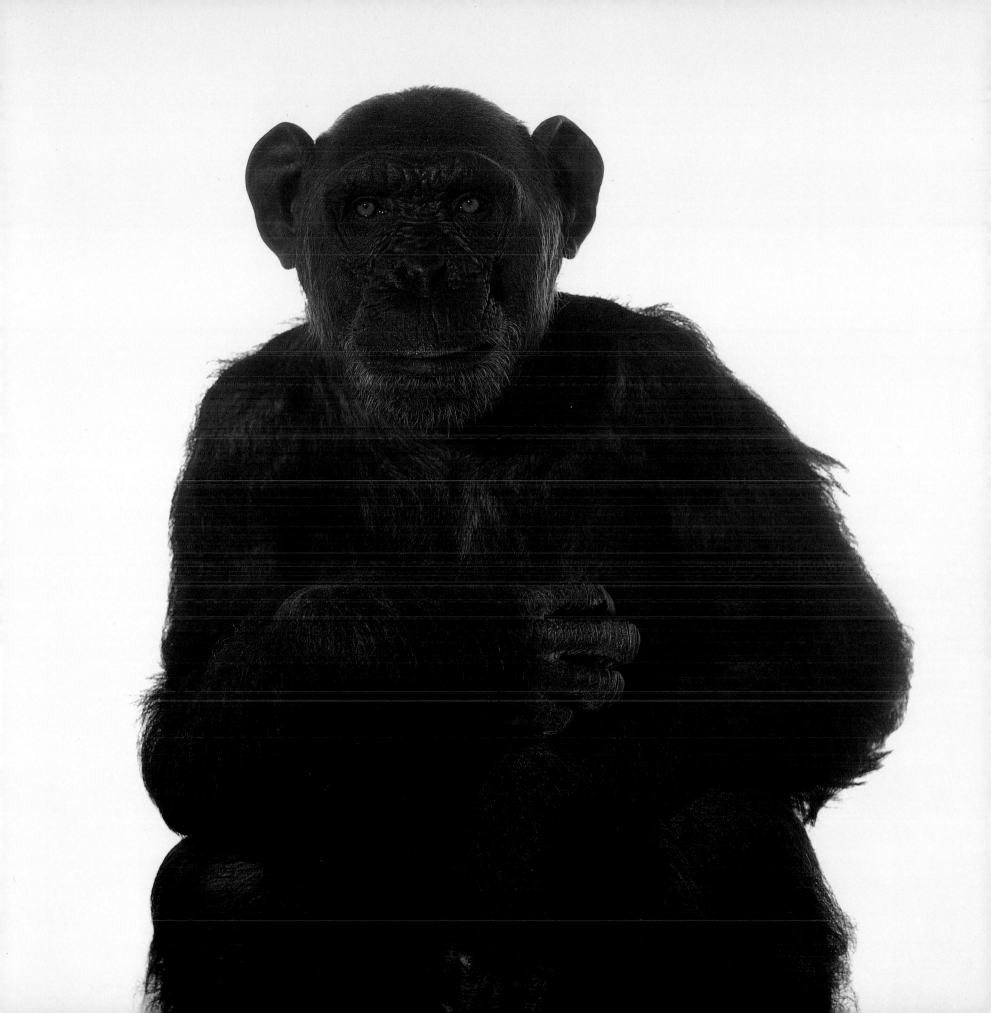

44

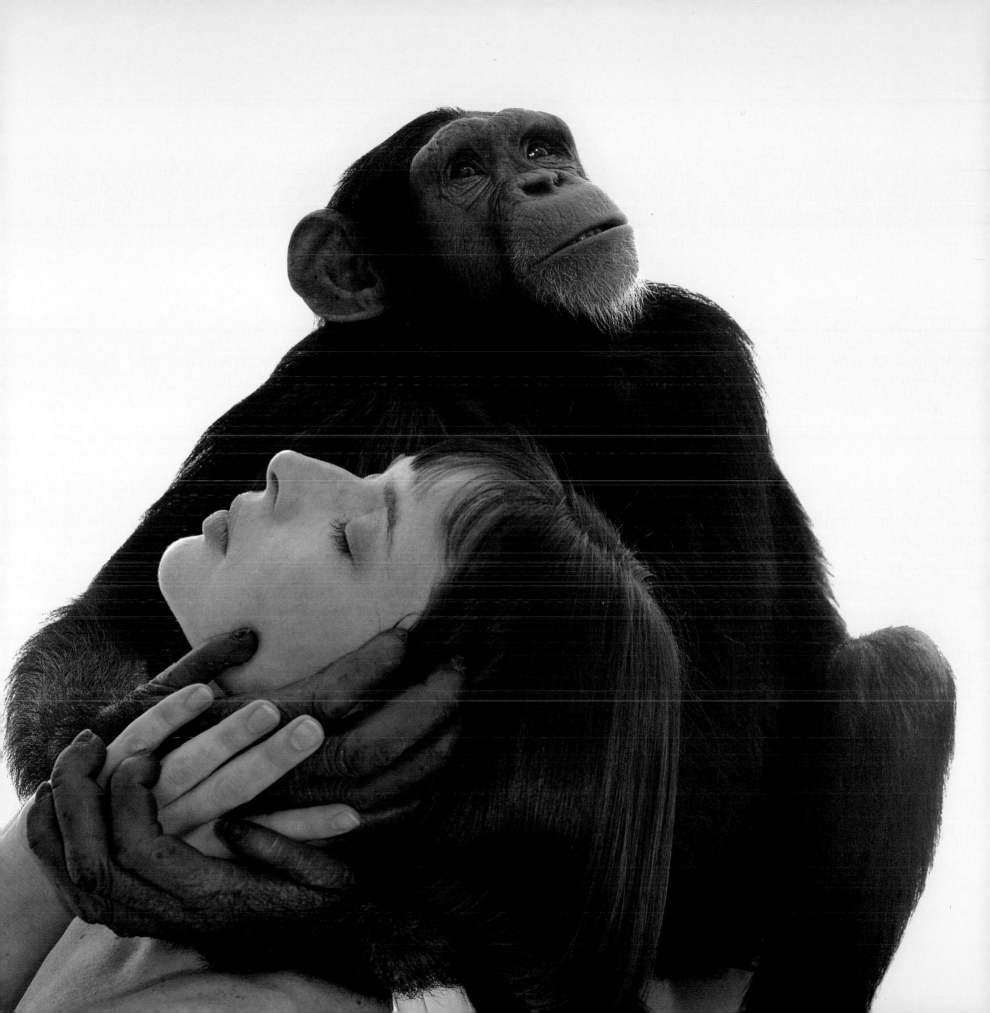

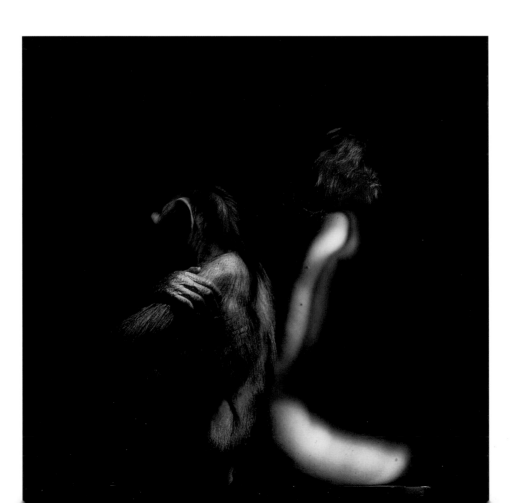

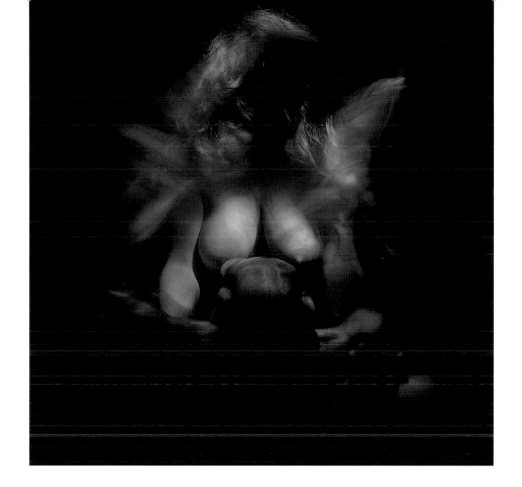

47

The ultimate *Boundary* between humans and nature is death.

The passage

from

life

to

death

reveals the basic lie

of anthropocentrism:

Atom

by

Atom,

the human and the natural

are

unmistakably

Fused.

Does the self then,

at last,

accept the nature

it has been

conditioned

to

fear?

50

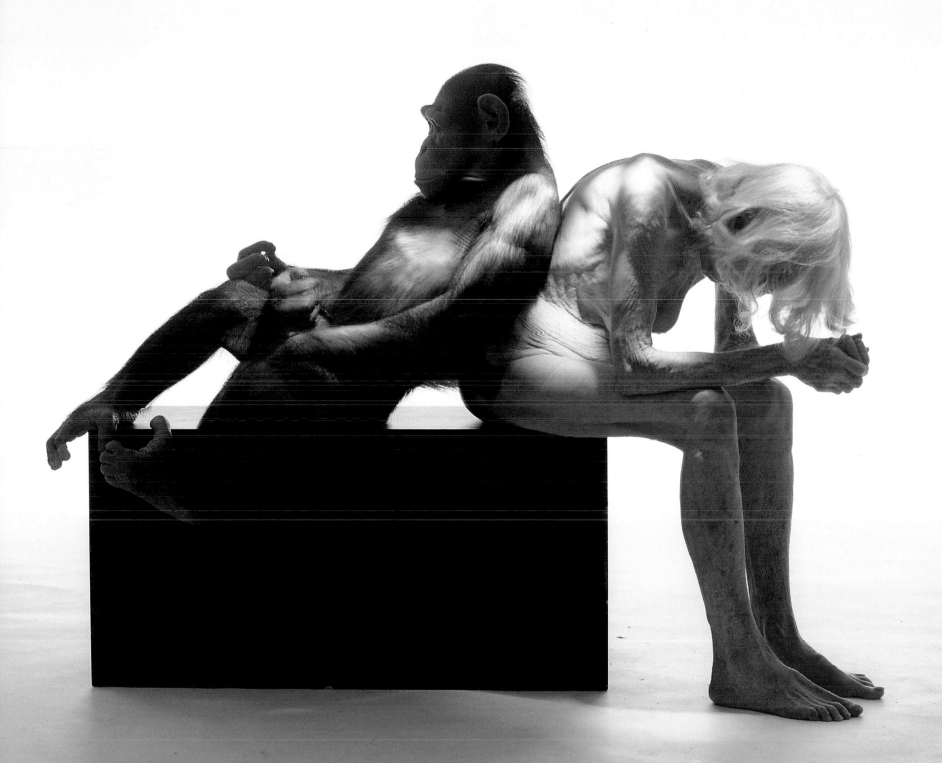

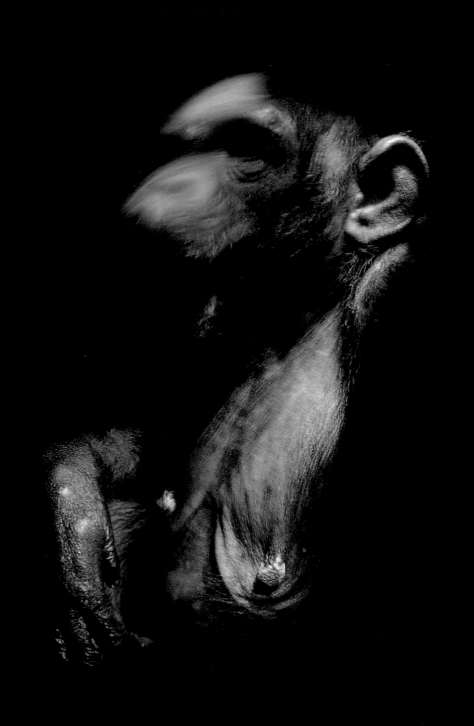

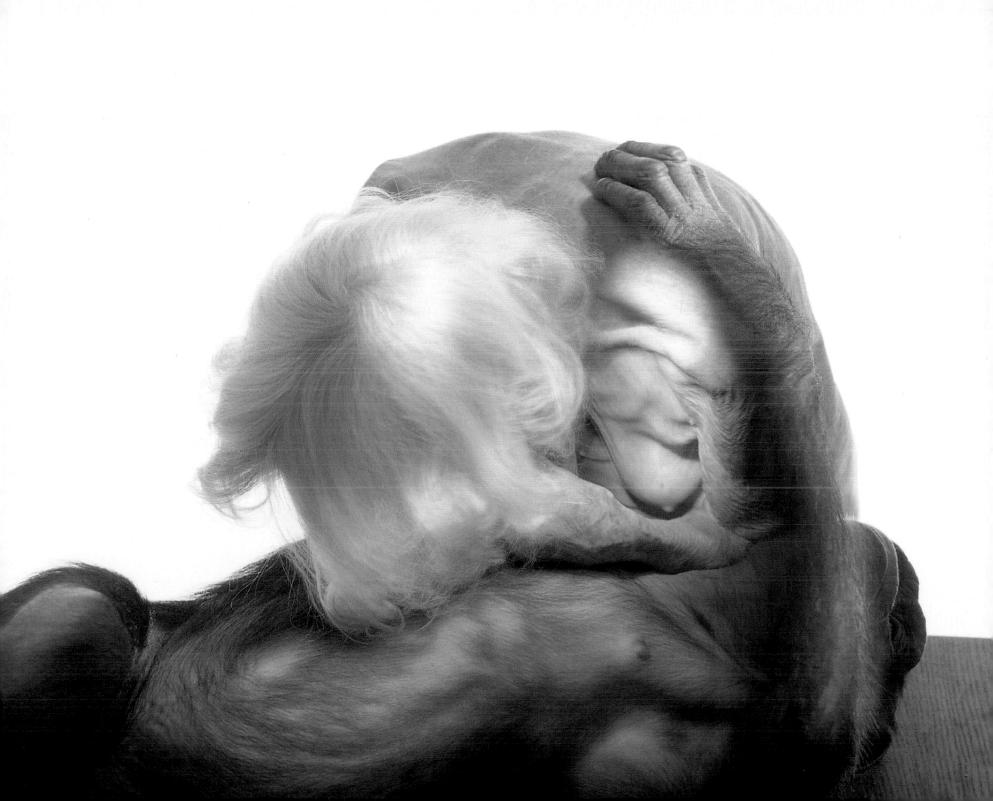

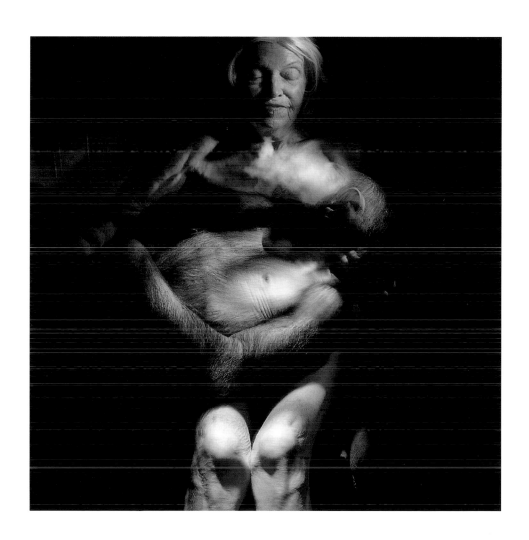

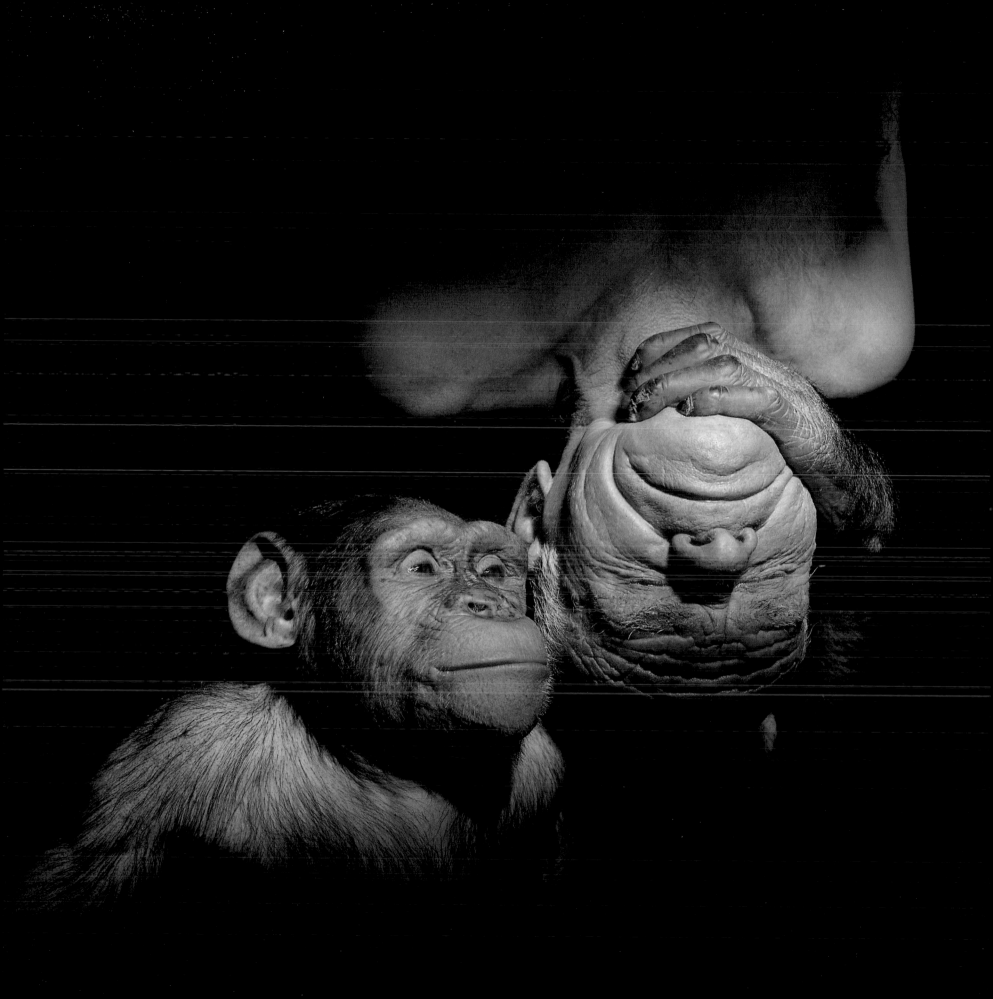

We

have continually

Searched

for new rationales

placing humans

at the pinnacle

of

evolution.

We exalted

our moral superiority,

our reasoning skills,

our technological capacity,

and our emotional depth.

But we discovered that we were

morally suspect,

emotionally similar,

rationally tenuous,

and that technology is not unique.

Are we now

mentally advanced enough

to stop insisting

that *Humanity*

is at the center

of

the

universe?

Faced

with the dysfunctions

of

our *Old* world

vision,

the survivors

must ask:

What Next?

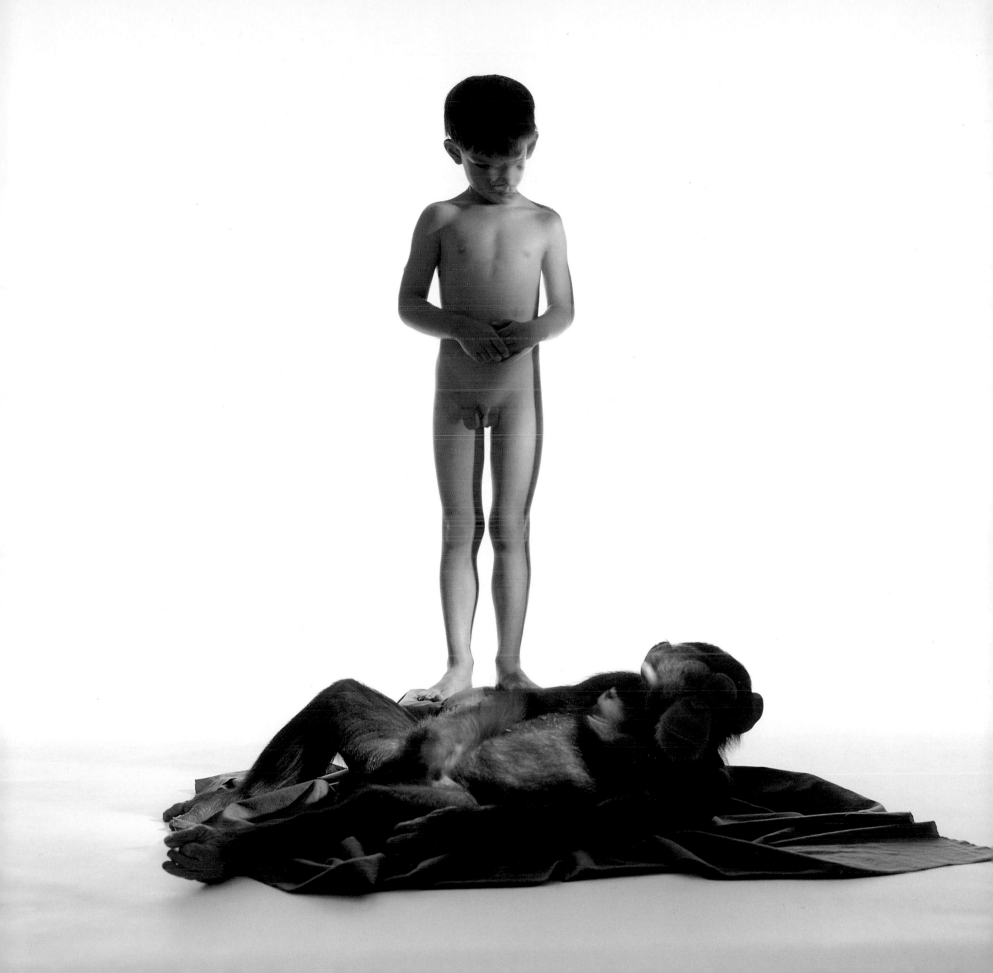

Origins & Sources

In essence, this portfolio was born from a lifetime of living and seeing the struggle between people and nature.
During photography on my previous book, *Survivors: A New Vision of Endangered Wildlife*, I was exceptionally
moved by my experiences with the great apes, and realized that there were more concepts
to explore through and with them. This book is the result.

My visual intuitions were guided in part by the philosophies of those who came before me.
Since the ground-breaking work of C.G. Jung early in the twentieth century, a variety of scholars in depth psychology,
mythology, philosophy, environmentalism, anthropology, and sociology have developed many of the ideas reflected by
the images and texts of this volume. A bibliography doing full justice to their wisdom would be a book in itself.
Some references given below are only the most generalized and simple points of entry to a given author's thinking—
but they at least trace the beginning of the trail into a fertile and endless forest.

Joseph Campbell, *The Masks of God* series (New York: Viking Penguin, 1964)

----, editor, *The Portable Jung* (New York: Viking Penguin, 1976)

----, *The Way of the Animal Powers* (London: Summerfield Press, 1983)

----, *The Power of Myth* (New York: Doubleday, 1988)

Bill Devall and George Sessions, *Deep Ecology* (Salt Lake City: Peregrine Smith, 1985)

Jared Diamond, *The Third Chimpanzee* (New York: Harper/Collins, 1992)

Jane Goodall, *Through a Window* (Boston: Houghton-Mifflin, 1990)

James Hillman, *A Blue Fire* (New York: Harper and Row, 1989)

----, *Anima* (Dallas: Spring, 1985)

----, editor, *Puer Papers* (Dallas: Spring, 1979)

Carl G. Jung, *The Collected Works of Carl G. Jung* (New York: Bollingen-Pantheon)

----, editor *Man and His Symbols* (London: Aldus, 1964)

Emma Jung, *Animus and Anima* (Dallas: Spring Publications, 1957)

Jerry Mander, *In the Absence of the Sacred* (San Francisco: Sierra Club Books, 1991)

David Miller, *The New Polytheism* (New York: Harper and Row, 1974)

Roderick Nash, *The Rights of Nature* (Madison: University of Wisconsin Press, 1989)

Jim Nollman, *Spiritual Ecology* (Bantam: New York, 1990)

Theodore Roszak, *Where the Wasteland Ends* (Berkeley: Celestial Arts, 1972)

Herbert Schneidau, *Sacred Discontent* (Berkeley: University of California Press, 1977)

Paul Shepard, *Nature and Madness* (San Francisco: Sierra Club Books, 1982)

George Steiner, *In Bluebeard's Castle* (New Haven: Yale University Press, 1971)

Frederick Turner, *Beyond Geography* (New Brunswick: Rutgers University Press, 1980)

George Williams, *Wilderness and Paradise in Christian Thought*

(New York: Harper and Row, 1962)

Designed by Michael Brock and Associates, Los Angeles,
in collaboration with James Balog

Printed in Italy by Arnoldo Mondadori

Photography editing by Howard Bernstein

Lighting was created with a combination of undiffused Hosemaster fiber optics and Comet strobes.
The film was exposed through Bronica cameras and an 80mm Zenzanon lens.

ACKNOWLEDGMENTS

Much of ANIMA was invented during the small hours of the night, far away from chimpanzees or
people or cameras. At such times, the terror of being alone in the creative process was overwhelming.
But I now realize, with pleasure, that the journey has not been so solitary after all. To the individuals and
organizations who helped bring this book to life, my deepest gratitude:

First, I thank the chimpanzees for their extraordinary presence, patience, and cooperation. Though I cannot know the
names they use in their native tongue, in English they are called: Sally, Bubbles, Lucy, Masey, and Annie; Milla,
Goblin, Mikey, Grumps, Pan, Dora, Pippa, and Cleo (of the Chimfunshi Wildlife Orphanage in
Chingola, Zambia); and Charlie and Mzee (of the Mount Kenya Wildlife Orphanage in Nanyuki, Kenya).

The spirited participation of my wonderful human models was equally critical:
Isabella Rossellini, Sean Graham, Maureen Kedes, Garrett Woo, Kelly Lester, Nicole Rudy, Bill Smith,
Aimee Becker, Charles Evans, Barry Wiley, Stephanie Feldman, Vivien Morris, Stephanie Sherwood,
John Budinger, Roubye Hart, Laura McMurray, Lee and Nino Surdo, Melissa Hoffs, and Stuart Swezey.

Katharina and Thomas Fårber and my parents, James and Alvina Balog, were vital allies at pivotal times. Larry Farrell
of Comet Lighting and Hilary Araujo of GMI Photographic donated the lighting equipment and cameras, respectively.
Odette Fodor of KLM Royal Dutch Airlines and Richard Goldman of the Goldman Foundation helped make travel to
Africa possible. David and Sheila Siddle opened their Zambian home to us and introduced us to many
extraordinary chimps; they and Carole Noon were comrades during many days of heated labor in the African bush.
Karl and Kathy Ammann gave access to the Mount Kenya chimps. Nikki Ashley, and Fred and Renate Winch, helped
with African logistics. Greg Lille, Vikki and Brian McMillan, Bob Dunn, and their co-workers endured requests for
"more". Kelly Corn, Dan Knudsen, Zachary Epps, and Sara Deal provided enthusiastic technical support.

Working with Michael Brock and Daina Howard-Kemp during the arduous process of book design
was a delight; they added much artistic insight to the final work. Many people were involved with editing
and sequencing of photographs and texts: Howard Bernstein, Amy Metier, Chuck Forsman, David Patryas,
Rebecca DiDomenico, Kris Lewis, and Elle Roper. Howard Chapnick gave wise counsel during uncertain times.
My production manager, Sport, gave all manner of organizational and technical assistance. Roy McCutchon and his
staff at Photocraft put exceptional effort into printing the exhibition. Other important help and friendship came
from: Mary Ellen Ford, Paul Picus, Zoshia Grzesk, Fred Woodward, Aaron Schindler, Joe Daniel, Valari Jack,
Anne Krause, Gail Cassling, Ray Hooper, Maureen Troy, Mara Hunter, Andy Kelly, and Carinne Meyn.

Finally, my most profound gratitude goes to my daughter Simone, who, by the simple fact of her spritely existence,
taught me more about anima and re-integration than I will ever understand consciously.
In the hope that she will grow up in a society more psychologically integrated than is my own,
I dedicate this book to her.

--James Balog

THE PHOTOGRAPHS

Copyright 1993 by James Balog

Published by
Arts Alternative Press
3200 Valmont Avenue, Suite 7
Boulder, Colorado 80301
(303) 444-5432

ISBN 0-9636266-0-4

Library of Congress Catalog Number:
93-090168